LogoMania **proper doesn't begin until page 75. Consider everything that precedes it as foreplay.**

First published in the United States of America
by Rockport Publishers, Inc., a member of
Quayside Publishing Group
33 Commercial Street
Gloucester, Massachusetts 01930-5089
Telephone: 978.282.9590
Fax: 978.283.2742

www.rockpub.com

Library of Congress
Cataloging-in-Publication Data
Gill, Bob
 LogoMania: sixty-eight logo problems and
solutions together with one logo problem solved
thirty one times by Bob Gill
 p. cm.
 ISBN 1-59253-252-7
 1. Design–process II. Title
 PN6084-D46F57 2006
 745-4–dc22

 2004025555
10 9 8 7 6 5 4 3 2 1 CIP

ISBN 10: 1-59253-252-7
ISBN 13: 978-1-59253-252-0

Cover and layout designed by Bob Gill

Printed in Singapore

Many thanks

Jack Gill, for your help in digitizing some of the artwork.

Christine Cirker, for seeing that the files were perfect for the printer.

Kristin Ellison, for her very helpful suggestions and for shepherding the book through Rockport.

Forget as much as possible.

Whatever the subject of the job, regardless of how familiar I am with it, I try and forget every image, every fact, every idea that's in my head about that subject.

I assume that most images, most facts, most ideas in my head were put there by the culture; television, magazines, films, etc., and that nothing in my head is original.

So if I am to have the best chance of seeing the subject in an original way, in a fresh way, I act as if I don't know *anything* about the subject. I research it; find out as much as I can about it so as to have as much new material to think about as possible.

The information I collect should help me think about something interesting to say.

That's the most important thing: having something interesting to say.

Design should be in the service of the statement, not the other way around.

5

Listening

Problem:
a monogram for
Formation Furniture,
makers of modular
seating.

I listen to the
statement that the
furniture is *modular.* It
tells me how the logo
should look.

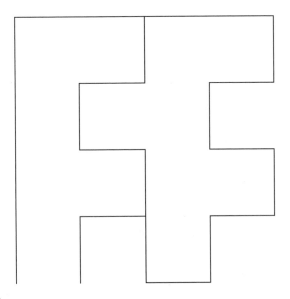

Reality

The audience who will see a company's logo is the same audience who will have seen the latest alien film, and the hottest music video, with special effects that are dazzling.

How can a graphic designer compete with this magic?

We can't. We have to go to the other extreme...to *Reality*!

We must take a look at the real world, and in effect, say to our audience, "Look! Have you ever noticed this before? Even though it was right under your nose?"

For example:
a very ordinary scale of miles on most maps

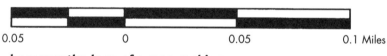

0.05 0 0.05 0.1 Miles

becomes the logo of a map-making company.

CommunityCartography

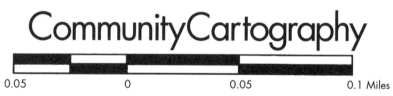

0.05 0 0.05 0.1 Miles

or a folded bit of
cardboard

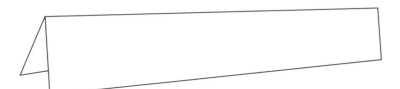

becomes a logo for a
company which
organizes conferences.

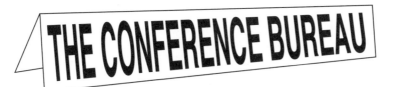

The problem is the problem.

If we, as graphic designers, are to arrive at interesting, original solutions that *also* communicate exactly what the client requires, we have to start by being critical of the problem.

The more interesting the problem, the more likely the solution will be interesting.

Here's an example:

AGM, a company which makes very small industrial models, wanted a monogram as their logo. (A conventional, boring problem.)

Original problem: design an interesting arrangement of an A, a G, and an M to be used on their stationery, their delivery vans, and on the side of their building.

Problem made more interesting: design an A, G, and M which communicates that the company makes very small models, and at the *same time*, is large enough so it can be easily seen on the side of their vehicles and on their building.

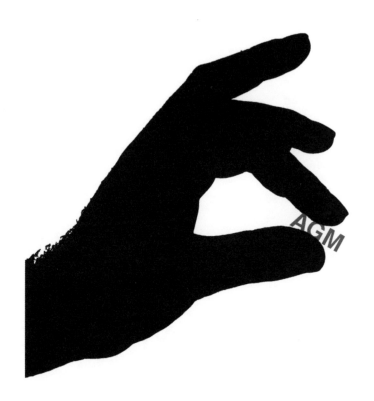

Problem:
logo for *Rent a New Yorker,* a company which supplies guides to tourists. Eventually, I decided that the most interesting thing I could say was that, unlike other tour guide companies who hire actors who know next to nothing about New York, their guides are *genuine* New Yorkers.

Question:
how can a logo communicate that they employ *genuine* New Yorkers?

Answer:
give the name of the company a *New York accent.*

I suggested changing their name from

Rent A New Yorker

to

Renta Noo Yawka

Having settled on the idea of spelling the name with a New York accent, I was ready to design.

I didn't want the audience to be distracted either by color or typeface.

I wanted them to *read* the statement.

I chose a very ordinary, legible type, Helvetica Narrow Bold, printed in black.

Renta Noo Yawka

Don't be afraid to exaggerate!!!

A company that gives cast-off
computers to schools and
charities has as its logo:

A computer is a terrible thing to waste.

When they asked me to use it
in an ad, I suggested it should
be in quotes. I thought it
would make the statement
more important.

"A computer is a terrible thing to waste."

And then, as long as it was used as a quotation, I thought it might as well be attributed to the greatest quotation generator of them all.

"A computer is a terrible thing to waste."
William Shakespeare

Problem:
APF for *American Physicians Fellowship*, an organization of American and Israeli doctors.

I make the problem more interesting: a monogram with English *and* Hebrew letterforms.

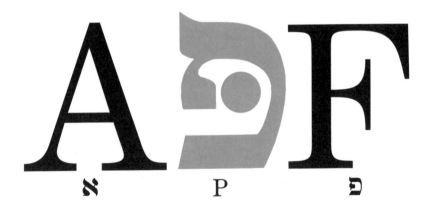

Don't *always* do as I say.

I arrived at this logo for *Van Nostrand Reinhold*, publishers, for no reason other than I liked the way the three letterforms fit together.

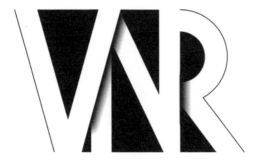

Almost all of the time, I have found that the best way of arriving at an interesting solution is by beginning with an interesting statement. Another possibility, however, is to begin with the most *obvious* statement.

Problem:
Cooking TV, a series of programs featuring a chef demonstrating various recipes.

The most obvious image is a chef in a television screen. Very boring.

However, I was reluctant to give it up, because it said *exactly* what the show was about.

Problem:
how can the most obvious image become a surprising one?

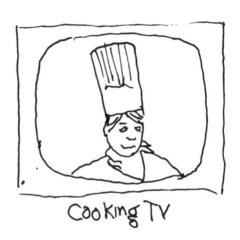

Cooking TV

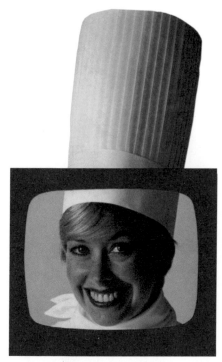

Cooking TV

Shaw's play, *Major Barbara*,
pits the Salvation Army
against capitalism.

More problems. More solutions.

The Drawing Breakthrough Book. I thought if I rendered this silly idea in a silly way, it would be okay.

The Writing Code, a series of films for public television on the invention and history of writing.

A series of films for television with contemporary plots related to the Ten Commandments.

I commissioned an engraver to carve a stone with the series title so that I could make a rubbing.

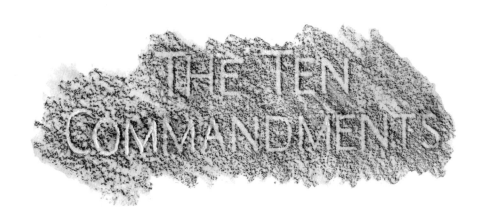

A series of radio programs about immigration at the beginning of the last century.

The photographs, from the museum on Ellis Island, are portraits of immigrants who arrived between 1900 and 1910.

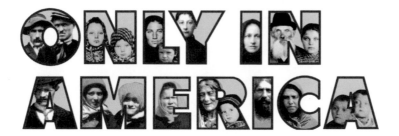

Two logos for *Blob*, a horror film. The first exaggerates the vertical axis of the photograph.

The second exaggerates
the horizontal axis.

Both distortions via
Photoshop.

A play with a rather bleak plot.

Winter

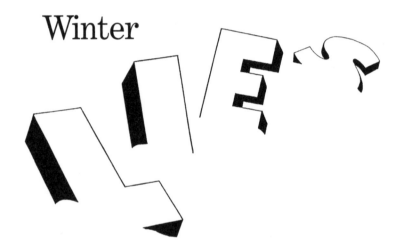

$Free.

Alan Fletcher, Colin Forbes, and I started the *Design and Art Directors' Association* in London and also designed their logo.

Not much of an idea here. We simply tried to get the letterforms as close together as possible.

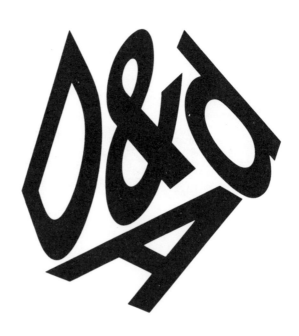

George Hoy, a typographer and letterer.

A bit of luck. I zoomed in on an alphabet, and George's initials were right in the center.

When a friend asked me to design a logo for his *personal stationery*, I immediately thought of his signature as the most personal image.

But it was also illegible.

So I added "subtitles."

Gene Searchinger

Although *Robert Rabinowitz, consultant,* is the name of his company, I suggested he use *Maven* (Yiddish for *expert*) as his logo.

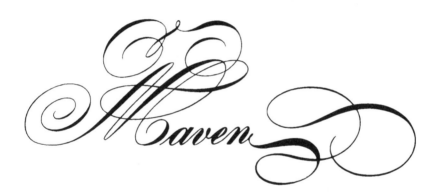

A *six-step design workshop* I occasionally give.

Problem:
Make it difficult to tell which finger was added.

34

A musical set in the depression of the 1930s inspired this ironic image.

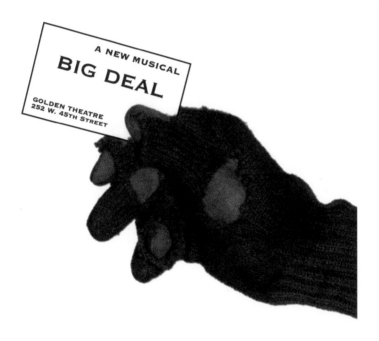

A NEW MUSICAL

BIG DEAL

GOLDEN THEATRE
252 W. 45TH STREET

A national chain of optometrists.

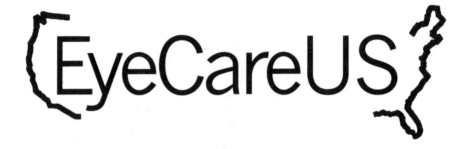

Problem:
logo for a paper
products chain.

Solution:
gives the name the
character of curved
paper.

PAPERMANIA

A line of romantic greeting cards.

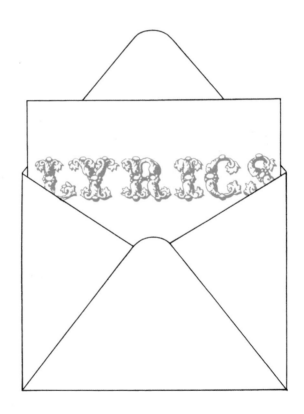

Logo for *Street Talk*, a book which documents the decline of the poster as an important advertising medium.

The collage of poster fragments which have seen better days also became the image on the book jacket.

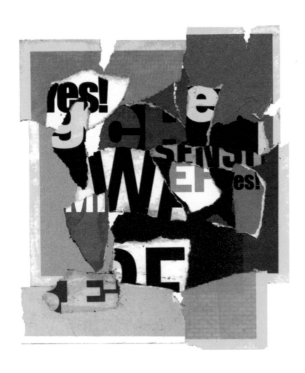

The design studio of a large printer wanted a logo which would appeal to *all* of their clients.

They said some were modern, some were traditional, and some were eccentric.

I suggested they always use *three* versions of their name.

Kynock Graphic Design
or Kynock Graphic Design
OR KYNOCK GRAPHIC DESIGN

An *"Event Producing"* company.

Their letterhead, business card and envelope list different events. Some serious. Some not so serious.

Commercials Fashion Shows **Bake-offs**
SENIOR PROMS Blind-Taste Tests **Sales**
Nast & Zalben Productions
Trysts **Picnics** *Sneak Previews* Block Parties
Hoedowns Christenings **Bar Mitzvahs**
Cruises **Wakes**
Rock Concerts Seances New **Product Launches**
Battle Reenactments *Regattas* Fireworks
Revolutions

How "avant garde"
can you get?

Problem:
logo for *Steve Baum
Productions*.

Baum wanted to
project a state-of-the-
art image for his
company.

As I felt that the hotter
the image, the faster it
would date, I went to
the other extreme.

Solution:
semaphore signal
flags. I found the flag
positions for the
company's initials,
and they became the
logo.

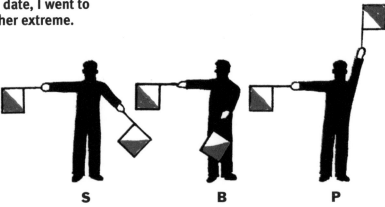

David Cammell, Hugh Hudson, and *Robert Brownjohn,* three swinging-sixties filmmakers started *CHB,* a production company.

The golfers came from a 1923 British type book. So did the initials.

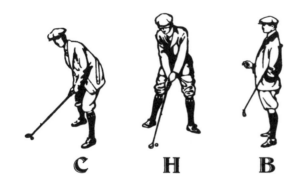

C H B

Rainmakers, an umbrella company, wanted a new logo. I questioned their name. I said that it didn't make sense for an umbrella company to call themselves *Rainmakers*.

They said they had been in business for many years, and they were very successful, and renaming the company was out of the question, and would I *please* design a new logo for *Rainmakers*.

After a heated discussion, we compromised.

They agreed to consider a new name.

I agreed that if they didn't like it, I would design a new logo for *Rainmakers*.

Eventually, I proposed that their receptionist answer their phone with, "Hello, it's raining."

The receptionist agreed, and they accepted my logo.

It's Raining!

They even allowed
some variations in their
catalogs and ads...

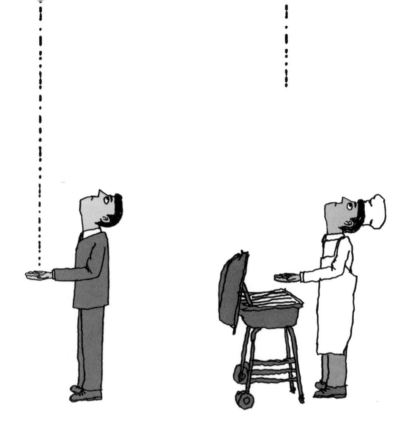

I bought these numbers at a local hardware store.

A good example of a "found object" as the right image for a friend's letterhead.

The logo for this film didn't need much more decoration than the typeface, Cooper Hilite.

in the shade

Face Off is a series of controversial debates held in various cities. I decided the shape of the space *between* the speakers was more graphic than the shape of the speakers themselves.

The World Goes Round, a zany comedy. See page 61 for another version.

Blond Educational is a subsidiary of Anthony Blond Ltd., publishers.

The "B" with its exponent "e" represents the relationship between Blond and Blond Educational.

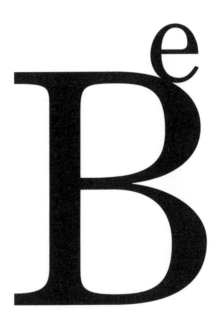

The Environmental Consortium, a think tank, wanted a logo to communicate the fragility of our planet.

Problem:
logo for a company
whose name is also its
web address. The
company markets the
tapes of two
comedians.

bobandray.com^{edy}

A series of programs for public television about the struggle of journalists around the world to report the truth, despite political stonewalling.

DE- MOC- RA- CY-

IN- TER- RUP- TED.

Louis Malle's India, a very personal documentary film by the great French director.

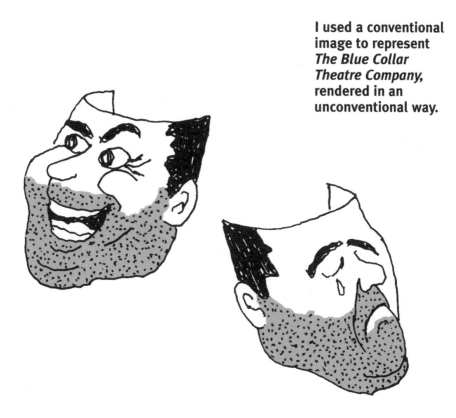

I used a conventional image to represent *The Blue Collar Theatre Company*, rendered in an unconventional way.

I tried to give a sense
of the size of the
vehicle used in location
filming by substituting
wheels for O's in the
company logo.

George Hoy did the
drawing.

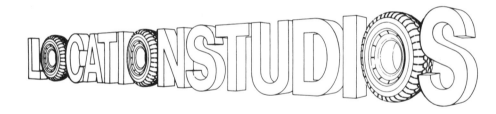

When I was asked to do a logo for *Wylton Dickson,* an aspiring film producer, I couldn't resist thinking of the two Hollywood producer clichés:

a vicuna overcoat casually thrown over the shoulders, and a Corona Corona, the biggest, most expensive cigar.

Eventually, I decided to go with a Corona Corona, as it fit, same size, across his letterhead.

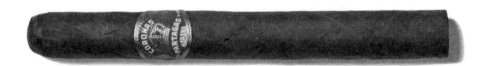

The High Rollers,
a jazz musical.

An *anti-smoking campaign* needed a logo to put people off the habit.

A computer program, *The Daily Drill,* lists various sport and entertainment events for each subscriber's locality.

An ironic logo for a very prestigious gathering of art directors and designers: the dinner honoring the latest inductees into the *New York Art Directors Club Hall of Fame*.

The logo was suggested by a clause in the contracts of LIza Minnelli and Chita Rivera, the two stars of the Broadway musical, *The Rink*, which guaranteed them equal billing.

The problem of representing the very "soft" profession of public relations is a difficult, interesting one.

Here's my version of getting the PR message out.

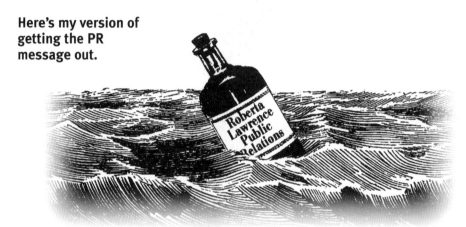

The *Nussbaum family*
wanted an N which
didn't look commercial,
to put at the top of
their stationery.

This is my idea of an
informal N.

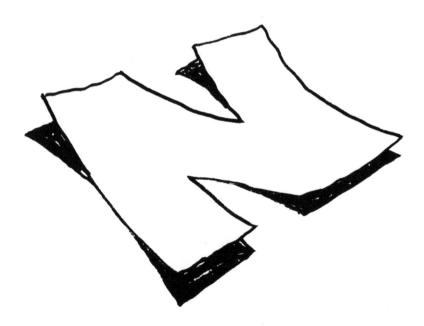

The "H" for *Harlech Television*, a Welsh company, was inspired by the lines running through tv images.

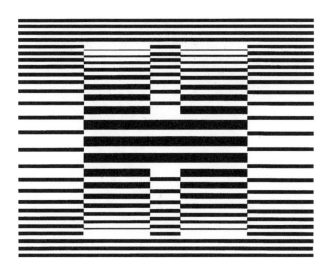

Auntie Mame, a comedy about a character who is very easily embarrassed.

I was asked to do a
logo for a perfume that
hadn't yet been named.
I assumed it would be
called L'amour, or
some other romantic
cliché. In the end, the
client abandoned the
project.

A simplified grill for
The Grill Room, a
steak house.

Ingo Finkey has an interesting frame shop. The solution: a frame with a twist.

Floodgate, a satirical play by Larry Gelbart about the Bush Administration's inept handling of the hurricane that devastated New Orleans.

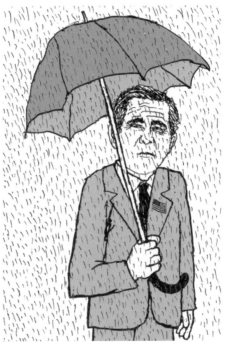

begins here.

A few years ago, *Applied Minds*, a very sophisticated think-tank, asked me to design its logo.

While some companies make one widget, in one color, in one size, *Applied Minds* represents the other extreme.

Typically, the staff of engineers, designers, computer programmers, model-makers, etc., of the company might be working on a robotic problem, an advanced method of recording sound, alternative energy possibilities, new navigation systems, a cure for cancer, and dozens of other problems involving various disciplines.

And all of this activity takes place within an unorthodox company culture that, although on the cutting edge of technology, doesn't take itself too seriously.

My first thought, after spending some time with the client, was that if they were around thousands of years ago, because they are so smart and innovative, they would have invented the wheel.

I presented two versions.

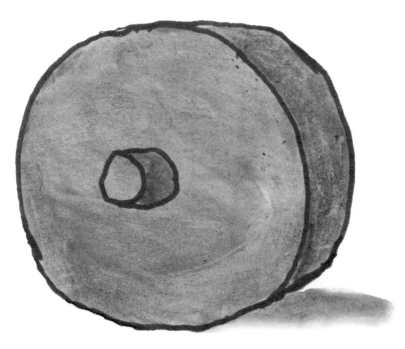

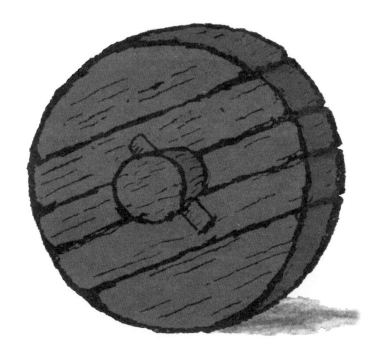

After my presentation was rejected, I came across a stock sign in a hardware store, which hotels and other institutions use to show the location of their stairwells.

I thought steps with some modification would make a handsome logo for a company reaching for something *just beyond what's possible*.

I tried some variations.

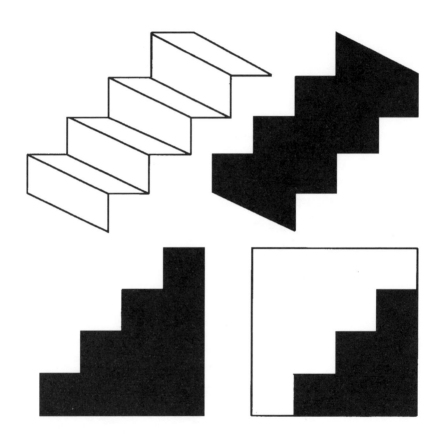

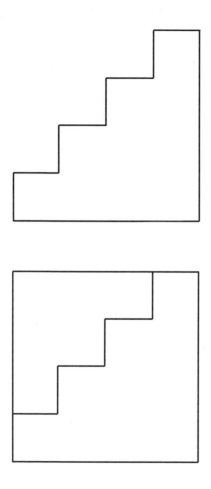

In the end, I decided that *less is more*.

My second presentation, opposite, was accepted.

Of all the logos that I have designed, this was the most ambiguous. In fact, it is the *only* ambiguous one that I have *ever* designed.

I had great trepidation before presenting the steps. If the client said, "How can I be sure that everyone who sees this logo would get the same message?" I would have had to concede that everyone would *not* get the same message.

But, fortunately, the question didn't arise.

Although, as I said, I avoid ambiguity, ambiguous images are not *necessarily* always inferior to those which communicate the same message to all. They can stimulate the imagination.

Or they can be confusing.

In the end, what makes communication—and logo designing in particular—so fascinating, is that even with focus groups, market research, and state-of-the-art branding specialists, hitting a bull's-eye is still an art, not a science.

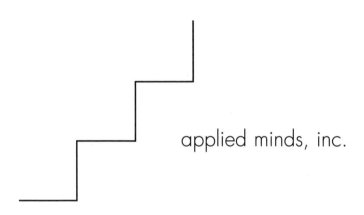

applied minds, inc.

The steps are cut out of the upper left-hand corner of the letterhead.

applied minds, inc.

The steps are also die-cut on the business card.

It was impractical to do this on the envelope.

applied minds, inc.

1209 Grand Central Ave.
Glendale, CA 91201
t: 818.545.14011
f: 818.244.0204
bran@appliedminds.net

Bran Ferren, Co-chairman
& Chief Creative Officer

applied minds, inc.

For years, I've been telling my students and anyone else who would listen that no matter how many times your amazing, absolutely brilliant work is rejected by the client, for whatever arbitrary, frivolous, dopey reason, there is *always* another brilliant and amazing solution possible.

Sometimes, it's even better.

As my experience with *Applied Minds* was typical—in that clients always accept my first or second solution, or they decide I'm the the wrong designer

for them and they get rid of me—I have never had a chance to test my *unlimited solutions to every problem* theory.

That's why I decided to design the *Applied Minds* logo again, and again, and again.

Thirty-one solutions are not quite *unlimited solutions*, but I trust my point will have been made.

Note:
There are no captions on any of the new logos that follow. If you can't understand why I chose a particular image, you'll find my reasons on pages 120 to 125.

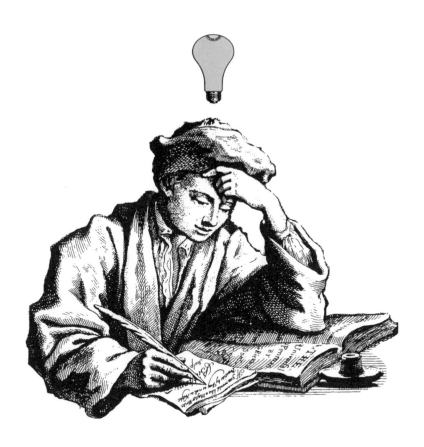

We're still trying to decide what to use as a logo.

Applied Minds

Applied Mindsssss

Finish

Start

Applied Minds

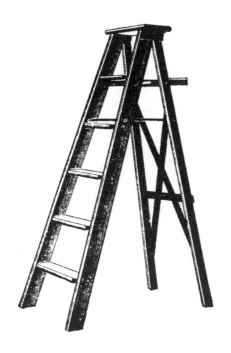

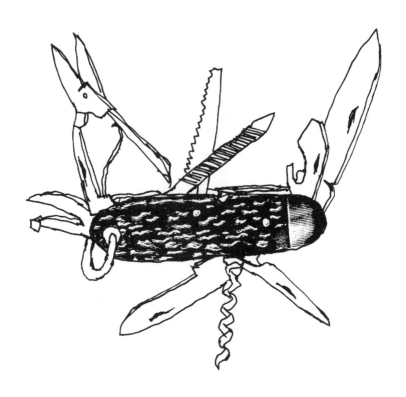

Applied s Inc.

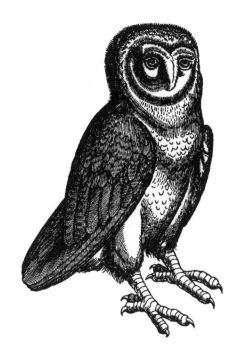

Notes on Applied Mind's logos, etc.

The company as
a serious problem
solver.

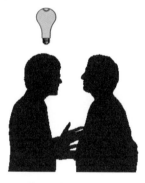

My first ideas were to
represent *Applied Minds*
as being in the "idea"
business.

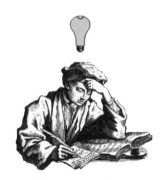

I prefer this version
with the lightbulb. I
like the contrast between
the nineteenth century
engraving and the
contempory bulb.

A "connecting-the-dots" reference in the shape of an A.

The A and M, when joined, and modified, form a simple memorable mark. The typeface: Futura Light.

A conventional bit of office imagery made eccentric.

We're still trying to decide what to use as a logo.

Imagine! Such a smart think-tank, and they can't make up their minds.

A company that doesn't go by the book.

Two versions of a company in the "big idea" business.

A company that can do the impossible: purple + green = orange.

Appl!ed Minds
Applied Mindsss

Slight changes in the spelling of the company name adds excitement.

Everyone in the company does the crossword in ink.

The company will get you there in the most expedient way.

Two images of business, which add electricity.

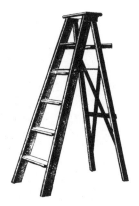

The company is the "Swiss Army Knife" of think-tanks.

Another version of a company that can do the impossible.

The company that's always reaching for something just beyond what's known. Two versions.

Applied 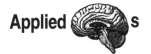s

Applied Minds or *Applied Brains*. I prefer *Applied Brains*. It's so much more aggressive.

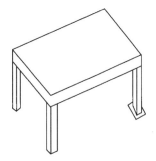

My favorite. As in the case of the step ladder, I like the idea of representing such a sophisticated company with such a low-tech logo.

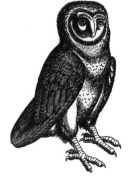

The company is very wise. So is the owl.

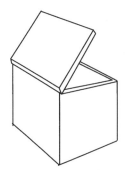

The company thinks *outside* of the box.

Clients

*Rejected

Bob Gill is a designer, an illustrator, a filmmaker, a copywriter, and a teacher.

After freelancing in New York, he went to London on a whim in 1960, and stayed 15 years. He started Fletcher/Forbes/Gill, a design office with the two brightest designers in England.

F/F/G began with two assistants and a secretary. Today, it's called *Pentagram,* with offices all over, except Tibet.

Gill resigned in 1967 to work independently in London. He returned to New York in 1975 to write and design *Beatlemania,* a live and multimedia history of the sixties for Broadway, with the painter, Robert Rabinowitz.

Gill is still working independently, and still teaching. He's had one-man shows in Europe, South America, and the U.S.

He was elected into the New York Art Directors Hall of Fame, and the Design and Art Directors Association of London presented him with its Lifetime Achievement Award.

He's now living in New York with his wife, Public Radio's Sara Fishko, their son, Jack, and their daughter, Kate.

Bob Gi

212•460•

Free Estimates, Free Pick-up

Easy Credit Arran

Email: bobgilletc@ny